Camille
Pissarro

By Joachim Pissarro

RIZZOLI ART SERIES
Series Editor: Norma Broude

Camille

Pissarro

(1830–1903)

"It is surely not difficult to see that our time is a birth and a transition to a new period."[1]

CAMILLE PISSARRO played a pivotal role in the history and development of Impressionism: older than any of the other Impressionists, even two years older than Edouard Manet, Camille Pissarro was referred to among his peers as *"le Père Pissarro."* His position as the dean of the Impressionists was heightened by his unwaveringly faithful commitment to the group exhibitions (1874–1886) that defined Impressionism: of all the Impressionists, Pissarro was the only one to exhibit at all eight exhibitions. He unsparingly devoted his energy to strengthen the all too often brittle bonds among the assertive individuals of the group. In addition, Pissarro developed an art that could be characterized more readily by its lack of characteristics than by any given formula. He, through his art, promoted a set of tenets and aesthetic options that largely contributed to anchoring the Impressionist era to the core of modernity.

Pissarro was born in 1830. The same year Charles X, the king of France, was toppled from the throne and fled into exile. With his departure went the last attempt to restore an absolute monarchy. Charles X was the last king of France by divine right (his successor, Louis Philippe I, became a king of the French people by virtue of a new constitutional right). The last two-thirds of the nineteenth century, which approximately include Pissarro's life span, can be understood as the gradual, if conflictual, emancipation of the state from the tutelage and influence of the Church. In 1904, a year after Pissarro's death, the separation of church and state was legally proclaimed in France, and the Dreyfus affair was pursuing its course. The Dreyfus affair in which a French officer, Captain Alfred Dreyfus, was convicted of treason, provoked the first instance of the defense of an individual's rights against the rights of an untouchable state authority. The gradual public recognition of the innocence of Dreyfus in 1897 was followed by the sluggish official acknowledgment of the illegitimacy of Dreyfus' condemnation for treason, which then led to his final rehabilitation, almost ten years later, in 1906. These two events were far from incidental to Pissarro's sensibility. In the last two-thirds of the nineteenth century there was an intellectual movement to dismiss the tutelage of religious values and any dogmas that claimed to lay the norms of practice for all—be it in religious, political, moral, or artistic terms. Throughout his life Pissarro unwaveringly endorsed and developed principles that are explicitly "modern." Pissarro was a committed atheist, or what he called a freethinker; politically, he was an anarchist. His close friend Jean Grave, the editor of the anarchist newspaper *Les Temps Nouveaux*, thus laconically defined anarchy: "Anarchy means the negation of authority."[2] In moral terms, Pissarro always fervently embraced liberal values, as can be seen in his many letters. This conviction expressed itself consistently in his passionate pleas for the right of every person to exert freedom of thought while respecting other people's different positions. As he explained to his son Lucien:

> I, who am not biased, see very clearly that there is little understanding around here, general ideas are being thrown around quite fiercely by some people. . . . Let everyone keep their ideas to themselves, for heaven's sake! This is what I advocate all the time. Think of the times that I have been in complete disagreement with you, Esther, Ricketts, and others! This does not stop me from seeing things differently when it comes down to practical life; one must understand that we are not all built the same way.[3]

In his unflagging defense of the individual's rights, Pissarro appears to have been an unconditional supporter of and contributor to modernity. Modernity in this context is defined as an epoch that "can and will no longer borrow the criteria by which it takes its orientation from the models supplied by another epoch; it has to create its normality out of itself. Modernity sees itself cast back upon itself without any possibility of escape."[4]

Modernity thus combines two complementary facets that are seen at work throughout Pissarro's life and art: first, the dismissal of all residues of rules of an uncheckable tradition; second, the laying down of rules that originate solely from the individual. These two moments (the dismissal of tradition and the re-creation of self-originated rules) are seminal and central to the development of Impressionism, creating a role for individual creation and innovation (the rules of artistic practice are self-instituted). At the same time, Pissarro argued, new ideas—as individual rules—need to be checked only with other colleagues and authors of comparable experiments. This new art, called Impressionism in 1874, could only measure itself with its equivalent, i.e., other individual forms of new art, since there was no traditional matrix left to grant it validity. Hence, Impressionism, as almost any other modernist movement to come, had little option but to constitute itself as a group in which each individual would develop stronger or weaker ties with the others. There are therefore two fundamental axes to Pissarro's development of Impressionism in opposition to the previous traditions that we might reflect on. One may wonder first what sort of rules or methods he installed in their place and second what were the intersubjective links he formed within the Impressionist group: who among all his colleagues, were those with whom he felt the greatest empathy and why?

Pissarro appears radically modern when compared with nineteenth-century academic contemporaries or with regular exhibitors at the salons or even with some of his closer colleagues. He was concerned with religious, moral, political, aesthetic, and artistic questions, but he was able to differentiate each realm into autonomous activities and to articulate a personal, humanistic reflection in each field.

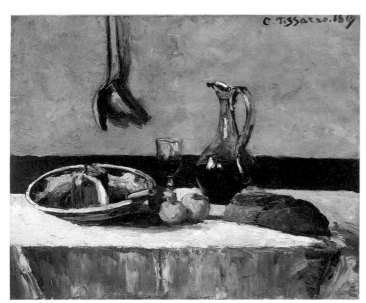

1. *Still Life*. 1867. Oil on canvas, 31⅞ x 39¼". The Toledo Museum of Art, Ohio. Gift of Edward Drummond Libbey

Pissarro's birth and his early self-taught artistic training, both far away from the mainstream academic establishment, are portentous of the autonomous position that he asserted for himself later on in life. He was born in Saint Thomas, in the Virgin Islands, when it was a possession of the Danish Crown. His father was a Frenchman from Bordeaux and a descendant of Portuguese Maranos (Jews who had been forced to convert to Christianity).

Certain moments in Pissarro's personal life are representative of his intellectual and moral independence. Pissarro married a Catholic-born woman, but in a civil wedding and against his mother's wishes. He himself professed a staunch disapproval of all religions. In 1897 his third son, Félix, was dying of tuberculosis. As Félix was on his deathbed, an Englishwoman tried to insist that Félix needed the spiritual aid of a clergyman. Pissarro angrily wrote to his second son to rescue his brother: "You should tell Mrs. Weston, on my behalf, that we are neither Protestants nor Catholics, and that we are nothing, and all we want is to be left alone, and that your brother needs rest and should only receive the visitors he likes."[5] Through his passionately felt plea for the respect of his son's indifference to religion, of his son's "nothingness," a strong echo of one of the main principles of humanism as defined through the Enlightenment can be heard: "Every animal is what it is; man alone is originally nothing at all. What man is to be, he must become."[6] Only a few months before his death, Pissarro was commenting on the relative merits (or lack of them) of Judaism and Catholicism, using a space-related and political metaphor: "Right or left, it is just the same."[7] Pissarro considered it a huge relief to have cast away all religions. The key notion was the riddance of uncheckable authority. To Pissarro, God was synonymous with dogmatic authority: "We no longer believe in authority or God! . . . religion, government, etc. . . .etc."[8]

This rejection, translated into the domain of art, resulted in a profound and long-sustained distrust of all the *écoles* and *académies*—as well as of any form of solidifying formulas. His frustrated experimentation with Neo-Impressionism offers one of the best examples of his willingness to experiment with unconventional ideas (see *Woman Breaking Wood*, plate 14).

Due to his self-made beginnings in Saint Thomas and Venezuela (1848–1855; he moved to Paris in 1855), Pissarro inevitably escaped any formative academic influences. As Cézanne, one of his closest pictorial allies, remarked: "He had the fluke to be born in the West Indies, where he learned how to draw without a master."[9]

At the beginning of his career, Pissarro produced a considerable number of drawings—in Caracas in particular, between 1852 and 1855. Looking at booklets and magazines, such as *L'Illustration*,[10] and seeing the work done by his older friend and colleague, the Danish artist Fritz Melbye, Pissarro learned the ropes of the art profession on his own and invented his own rules of procedure. In fact, Pissarro sustained a keen interest in drawing throughout his career. In his graphic experimentations, Pissarro, like Degas, subverted the traditional chain of elaboration of a work of art; among the 3,500 drawings he produced, very few can be regarded as preparatory works for a finished oil on canvas. Instead, his drawings may either have been produced as artworks in their own right or they may constitute the study of one element, one facet, for a larger composition, for another drawing, or as a point of reference for a study in a different medium. One could say that for himself, Pissarro autonomized the medium of drawing by emancipating the technique from the traditional hierarchical chain of composition, whereby the drawing was a means to an end. This in turn applies to his approach towards all techniques and media, as can be seen in works such as *The Poultry Market at Pontoise* (fig. 3). In fact, in this, as in many other ways, Pissarro was particularly close to Degas, with whom he collaborated on certain prints between 1878 and 1882.

Pissarro not only contributed to subvert and reinvent the role of drawing but, following Degas's advice, he clearly saw in drawing a means to contravene traditional academic influence. In 1883 he wrote to his son Lucien, who was then living in London, recommending the practice of drawing to him in order to escape the pernicious impact of Alphonse Legros, whose teaching at the Slade School of Art led to formulaic and official forms of art. In order to counteract what Pissarro called Legros' "preconceived method,"[11] Degas and Pissarro suggested to Lucien that he continue attending his course and work on his academy lessons, but that back at home he should redraw the same subject from memory. Pissarro explained the result: "You will find it hard but there will come a time when you will be astonished by the ease with which you will have remembered the forms, and what is extraordinary, the observations that you make from memory will be stronger, more original than those done directly from life; consequently, your drawing will be artistic and it will be all your own work."[12]

For Pissarro, blind imitation of a "preconceived method" or of any academic dogma was nothing short of aesthetic slavery. In fact, assigning any external task to art was perceived by Pissarro as being just as pernicious as following a "preconceived method." Another form of risk to avoid was to assign an illustrative function to art. He had little but contempt for art that was stained with that "taste for illustration and that despicable facility."[13] It is therefore pointless to search in Pissarro's art for a pool of signs of his ideology transposed into a two-dimensional visual language; had this illustrative task been his aim, he would have achieved it more effectively by simply being a political cartoonist or a newspaper illustrator such as Jean-Louis Forain. Pissarro's definition of his art radically departed

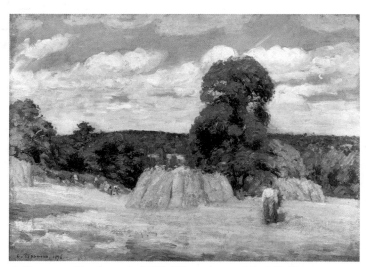

2. *Harvest at Montfoucault.* 1876. Oil on canvas, 26 x 36". Musée d'Orsay, Paris. ©Photograph 1992 Réunion des Musées Nationaux

from any such associations. Occasionally, however, he advised his son Lucien to send an illustration to Grave's anarchist publication. But even then Pissarro seemed to advocate that any subject matter would do, "provided that it was well done."[14] Giving his son what seemed the best subject for a contemporary illustration of an anarchistic subject matter, he wrote, "Think about Brueghel the Elder's *Parable of the Blind.*"[15] When asked to supply an illustration to *La Plume,* another anarchist newspaper, Pissarro replied that he had fortuitously done a drawing depicting coal carriers in the port of Rouen; had it not been so fortuitous, he explained that he would have had to send them a drawing of a tree trunk! Pissarro then explained to his correspondent: "I asked myself: what could a man of letters understand by anarchist art? Forain? So it seemed to me. Is there an anarchist art? Is there? Evidently, they don't know. All art is anarchist when it is beautiful and well done! That's what I think."[16] A tree trunk or a coal carrier can serve just as well as an anarchist drawing, provided that it is beautiful and well done. There is no such thing as an anarchist art because any art can be anarchistic, Pissarro believed. The criteria are beauty and technical mastery (fig. 2). This explains of course why Pissarro could see in Degas a streak of anarchism, "in art, of course, and unknowingly so!"[17] Pissarro's principal aesthetic thesis, which sustains all his art, was that art should not be subservient to, or dependent on, an external cause or an external message, be it a religious message ("religious, mystic, mysterious ideas"[18]); be it a social or political cartoon (as by Forain); be it a historical narrative (such as those by the genre and military painter Jean Louis Ernest Meissonier); or be it a sentimental, pretty, moving story (as illustrated by Jean François Millet, the Barbizon painter).

This also precisely explains what Pissarro meant when he wrote, "I firmly believe that our ideas, pervaded with anarchist philosophy, rub off on our work and for that reason are in antipathy to contemporary ideas."[19] Once rid of the idea that art's purpose is to illustrate a message, he believed that artists could return to more modern—i.e., anarchistic— ideas and an art based on "free sensations." As he stated, what defines primordially the quality of good, modern, anarchistic art, is the "freedom of your own brush."[20] Pissarro was thus one of the first artists in France to insist that there is no contradiction between a genuine concern for producing beautiful art devoid of any programmed message and a genuine, though dissociated, commitment to morals

and politics. Pissarro carried out a genuine reflection on both fields with the same complete integrity; yet in his mind neither field was ever determined, influenced, or exclusively explainable by the other. At the most critical moment of the Dreyfus affair, Pissarro voiced his genuine liberal creed: "I believe and I hope that free men will end up by having the upper hand."[21] In the same letter, he referred to going back to his work as though nothing had happened: "In spite of the serious events which are taking place in Paris and in spite of my own concerns, I must work at my window as if nothing was happening."[22]

In his rejection of all "preconceived methods," his search for a cause or for a solution to the problems of art outside art, Pissarro was in fact extremely close, knowingly or not, to the German aesthetician and dramatist Gotthold Lessing. In his classic treatise on aesthetics, *Laokoon,* Lessing demanded that a work be called art only if it served no external purpose (in particular, no religious purpose): "I would like a work of art to be called a work of art only when the artist truly reveals himself, that is to say when beauty is his only aim."[23] This definition itself is the key to Pissarro's assertive aesthetic system that is found throughout his five-volume correspondence and through myriad allusions he made. Any work of art, Pissarro determined, must respond to the inner logic and the inner impulses of the artist. This is called "*la sensation*" and corresponds directly to Lessing's insistence that the artist show himself truly as himself.

Pissarro repeated this obsessively: "Don't forget only to be yourself. However this cannot be achieved without efforts."[24] To this end, the artist must learn to see by himself [25] through the constraints of a chosen technique. Hence, it is no surprise that Pissarro emphasized consistently the value of sincerity,[26] which meant to be true to oneself and to avoid the artificial, made-up effects of what he called "hypocritical art." Following the logic of Pissarro's system, one then naturally falls back on the original founding condition of all great art, i.e., "absolute liberty."[27] This absolute liberty can be read, with different implications, as a political concept (a rejection of all institutional authorities, censorship, official taste, etc.) and as an aesthetic concept (liberty defines the gesture of founding one's own rules of practice, of following one's own sensations). This concept of liberty, within Pissarro's system, is the unifying keystone that holds together the whole vault of his artistic philosophy. As usual, though, this concept is intertwined with a paradox: this fundamental liberty is not the liberty to do anything, but the liberty to impose on oneself one's own rules, one's own sensations: "Work, search, do not bother too much with other concerns, and it will come. But you must have perseverance, willpower and free 'sensations,' detached from everything else other than your own 'sensation.'"[28] It was one of Pissarro's great strengths to have realized that there is no contradiction between liberty (as a political and as an aesthetic condition of practice of art) and the rigorous necessity of reaching one's own "individuality,"[29] in "searching for our own elements in what surrounds us, with our own senses."[30] This is what Pissarro called "genius," referring to Corot,[31] and also to Manet, Goya, Rembrandt, and Claude,[32] whom he considered direct predecessors of the Impressionists.

Pissarro's Impressionism was of course intimately related to that of the artistic search of the individuals with whom he shared most closely the same aesthetic preoccupations.

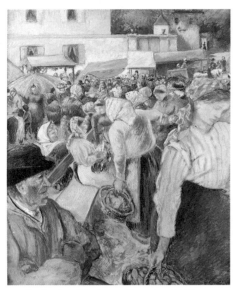

3. *The Poultry Market at Pontoise*. 1882.
Distemper and pastel on canvas, 32 x 26".
Private collection, U.S.A.

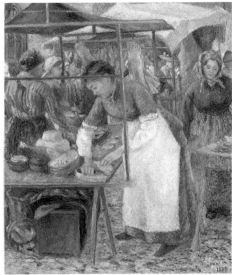

4. *The Pork Butchers*. 1883. Oil on canvas,
26 x 21". The Tate Gallery, London/Art
Resource, New York

Degas, Cézanne, and Monet, in particular, along with
Pissarro, defined a close-knit, intersubjective sphere of
artistic invention. What brought these individuals together,
in Pissarro's mind, was that they invented, each within his
own terms, "an alternative vision, a highly individual and
modern spirit."[33] How did the Impressionists manage to
succeed together? Pissarro explained: "By making real
progress, by sticking together, and never missing their
'free' exhibitions."[34] Their commonly shared aim always
remained "to look at nature with our own modern tempera-
ment,"[35] or to invent a "tradition of modern art" that ought
to be modified "from the individual's point of view"[36] (figs.
3 and 4).

We now return to the initial question of what makes
Pissarro's art modern. Pissarro was born in 1830. Toward the
very end of his life, he noted at the *Exposition Universelle* in
1900 that the Impressionists were well represented, having
finally made their place in history, and that they, including
Cézanne, would now be sure to create a sensation. He ex-
plained: "We followed on the heels of the School of 1830."[37]
Metonymically, his birth year was also understood as the
group name of the predecessors of the Impressionists, other-
wise known today as the Barbizon school. Pissarro a decade
earlier explained what the school of 1830 signified to him:
"The art of 1830 is Corot, Courbet, Delacroix, and Ingres! . . .
and it is eternally beautiful."[38] The paradox is obvious; the
school (Barbizon) receives its name from the year when the
group was formed. The year 1830 (the birth year of the dean
of Impressionism) assigns as well an inescapably transitory,
ephemeral, historically definable dimension to the Barbizon
group, yet their art is "eternally beautiful." This paradox
precisely echoes the very definition of modernity offered by
Charles Baudelaire, which the philosopher Walter Benjamin
after him radicalized: "Modernity is the transient, the fleet-
ing, the contingent; it is one-half of art, the other being the
eternal and immovable."[39] All of Pissarro's work illustrated
here reveals this tension by offering spaces infused with
paradoxes and sometimes fragile equilibria, at the inter-
section between time and eternity. Courbet's caricature
peeping over the stout, unkempt silhouette of a partly sar-
donic and partly benign, partly vulnerable and partly arro-
gant, partly familiar and partly odd-looking Cézanne (plate
7) offers the best metaphor of this paradoxical definition of

Pissarro's (and Cézanne's) modernity. Besides the obvious
humor inherent in the whole composition, this work also
illustrates Impressionism coming out of "*l'art 1830*": it
erupts like a breakthrough of normality; at the same time,
it satisfies "for a moment the immortal longing for beauty—
a moment in which the eternal comes into fleeting contact
with the actual."[40]

NOTES

1. G. W. F. Hegel, *The Phenomenology of the Mind*, introduction by George Lichtheim (New York: Harper and Row, 1967), p. 20.
2. Jean Grave, *La Société mourante et l'anarchie*, preface by O. Mirbeau (Paris: Stock, 1893), p. 1.
3. Janine Bailly-Herzberg, *Correspondance de Camille Pissarro*, Vol. IV (Paris: Editions du Valhermeil), pp. 485–486.
4. J. Habermas, "Modernity's Consciousness of Time," *The Philosophical Discourse of Modernity*, trans. Frederick G. Lawrence (Cambridge, Mass.: MIT Press, 1987), p. 7.
5. Bailly-Herzberg, Vol. IV, p. 386.
6. Johann Gottlieb Fichte, *The Science of Rights* (1796), trans. A. E. Kroeger (New York: Harper and Row, 1970), p. 119.
7. Bailly-Herzberg, Vol. V, p. 350.
8. Bailly-Herzberg, Vol. IV, p. 271.
9. P. M. Doran, *Conversations avec Cézanne* (Paris: Macula, 1978), p. 121.
10. Bailly-Herzberg, Vol. IV, p. 291.
11. Bailly-Herzberg, Vol. I, p. 224.
12. Bailly-Herzberg, Vol. I, p. 218.
13. Bailly-Herzberg, Vol. III, p. 323.
14. Bailly-Herzberg, Vol. IV, p. 230.
15. *Ibid.*
16. Bailly-Herzberg, Vol. III, p. 261.
17. Bailly-Herzberg, Vol. III, p. 63.
18. *Ibid.*
19. *Ibid.*
20. Bailly-Herzberg, Vol. V, p. 367.
21. Bailly-Herzberg, Vol. IV, p. 434.
22. *Ibid.*, p. 435.
23. G. E. Lessing, *Laokoon*, French trans. Vol. IX, 1964, p. 93, quoted by T. Todorov, *Les Genres du discours* (Paris: Seuil, 1978), p. 33.
24. Bailly-Herzberg, Vol. I, p. 264.
25. *Ibid.*, p. 215.
26. *Ibid.*, p. 211.
27. Bailly-Herzberg, Vol. IV, p. 207.
28. Bailly-Herzberg, Vol. III, p. 256.
29. Bailly-Herzberg, Vol. IV, p. 462.
30. *Ibid.*, p. 458.
31. *Ibid.*, p. 463.
32. *Ibid.*, p. 462.
33. *Ibid.*
34. *Ibid.*, p. 144. The first Impressionist exhibition was in 1874 and the last being in 1886.
35. *Ibid.*, p. 504.
36. *Ibid.*
37. Bailly-Herzberg, Vol. V, p. 83.
38. Bailly-Herzberg, Vol. I, p. 100.
39. C. Baudelaire, "The Painter of Modern Life," *Selected Writings on Art and Artists* (New York: Harmondsworth, 1972), p. 403.
40. J. Habermas, p. 9.

FURTHER READING

Adler, Kathleen. *Camille Pissarro, A Biography*. London: B. T. Batsford Ltd., 1978.

Arts Council of Great Britain and the Museum of Fine Arts, Boston. *Pissarro*. London, Paris, Boston, 1980.

Brettell, Richard. *Pissarro and Pontoise, The Painter in a Landscape*. New Haven and London: Yale University Press, 1990.
_____ , and Christopher Lloyd. *A Catalogue of the Drawings by Camille Pissarro in the Ashmolean Museum, Oxford*. Oxford: Clarendon Press, 1980.

Lloyd, Christopher. *Camille Pissarro*. London: Macmillan, 1981.

Pissarro, Ludovic Rodo, and Lionello Venturi. *Camille Pissarro, son art—son oeuvre*, Vols. I and II. Paris: Paul Rosenberg, 1939 (new edition, San Francisco: Alan Wofsy Fine Arts, 1989).

Reff, Theodore. "Pissarro's Portrait of Cézanne," *Burlington Magazine*, November 1961, pp. 627–633.

Rewald, John. *Camille Pissarro*. New York: Abrams, 1963 (republished in concise form, 1989).

Shikes, Ralph E., and Paula Harper. *Pissarro, His Life and Work*. New York: Horizon Press, 1980.

This book is dedicated to Anne Thorold. —J.P.

First published in 1992 in the United States of America by Rizzoli International Publications, Inc.
300 Park Avenue South
New York, New York 10010

Library of Congress Cataloging-in-Publication Data
Pissarro, Joachim
 Camille Pissarro/by Joachim Pissarro.
 p. cm.—(Rizzoli art series)
 Includes bibliographical references and index
 ISBN 0-8478-1582-X
 1. Pissarro, Camille, 1830–1903—Criticism and
 interpretation.
I. Pissarro, Camille, 1830–1903. II. Title. III Series.
ND553.P55P488 1992
759.4—dc20 92–15547
 CIP

Series Editor: Norma Broude

Series designed by José Conde and Betty Lew/Rizzoli

Printed in Singapore
Plate 1: photograph by W. Dräyer (Bürhle Collection)
Plate 2: photograph by David Heald

Front cover: see plate 5

Index to Colorplates

1. *Negress Carrying a Pitcher on Her Head, Saint Thomas.* c.1854–1858.
This painting's directness and utter lack of aesthetic or sentimental contrivance point to Pissarro's long-standing concern for depicting simple scenes from daily life that make no class, gender, or race distinctions. Such a pictorial representation yields elevating results, as the lustrous, lush, and richly worked surface of this canvas demonstrates.

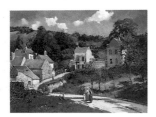

2. *The Hermitage at Pontoise.* c.1867.
This picture's formal structure holds together a system of several thematic oppositions. For instance, the bright, early spring light that falls vertically on this scene is blocked by the delicate parasol held by the artist's wife in the foreground.

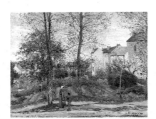

3. *Landscape in the Vicinity of Louveciennes (Autumn).* 1870.
Although the canvas is horizontal, this picture has a pronounced vertical composition. Two trees thrust upward, defining an intermediate vertical space, within which the two standing figures converse. The houses on the right reinforce the vertical emphasis.

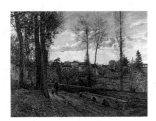

4. *Louveciennes.* 1871.
This complicated composition is made up of three or four smaller compositions demarcated by the tree trunks that unify the rhythm of the picture. The poetic qualities of this work are emphasized in the twilight and autumnal nuances of the shade and the figures of a woman and her child.

5. *Lordship Lane Station, Dulwich.* 1871.
This painting was executed in the spring of 1871, while Pissarro was living in the southeastern suburbs of London. Although the relevance of Turner's *Rain, Steam and Speed* has been emphasized, the clarity of Pissarro's structural pictorial concerns distinguish this painting as his own.

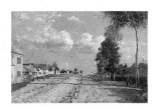

6. *The Rocquencout Road.* 1871.
This painting's construction is unusual. A rectangle within the canvas is formed by the low base of the cumuli clouds, the tree trunk, the first shadow crossing the road, and the right edge of the house. Fundamental elements pertaining to human life are contained within this inner rectangle, yet these forms are distanced from the rest of the picture.

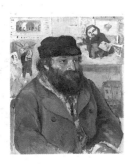

7. *Portrait of Cézanne.* 1874.
The leathery paint surface may refer to Cézanne's unkempt appearance and to his own thickly encrusted canvases. Humor and double entendre pervade the meaning of this extraordinary work, whereby a political newspaper satire of Adolphe Thiers is juxtaposed against a cartoon of Courbet, who seemingly peeps over Cézanne's shoulder.

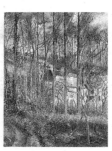

8. *The Côte des Boeufs, Pontoise.* 1877.
In this painting Pissarro depicted a radical, complex fragmentation of reality. Whereas *Louveciennes* (plate 4) can be divided into distinct sequences, this painting stems from the juxtaposition of eight to ten intertwined intervals. The bulk of trees are almost sculptural: they ooze paint, and their contours are etched into the paint's surface.

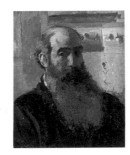

9. *Self-Portrait.* 1873.
The colors used in this self-portrait are restrained, revolving around a harmony of warm tones—sienna, dark browns, grays, and ochers with a prevailing ocher-pink-vermilion undertone. Two colors detach themselves from this color scheme—the tepid red of the roofs and the pale greens of the trees seen in the paintings hanging on the wall.

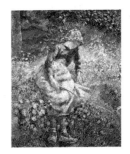

10. *Young Girl with Stick, Seated Countrywoman.* 1881.
The space depicted in this figure painting offers no point of reference, no landmark—we are lost. The model herself is lost in thought. The stick is loose in her hand; no longer used for herding sheep, it has become a plaything (perhaps a metaphor for the artist's brush, which no longer serves a traditional function but instead catalyzes the artist's sensations).

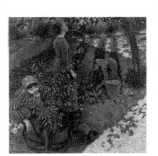

11. *The Apple Pickers.* 1886.
"The figures seem to move in a dream; we are on the thither side of life, in a world of quiet color and happy aspiration," wrote George Moore about this painting in 1906. The divided brushwork and chromatic scale of contrasts used here have assigned this painting an important position within the artist's Neo-Impressionist phase.

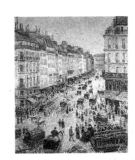

12. *The Rue Saint-Lazare.* 1893.
From 1893 until his death in 1903, Pissarro devoted an important part of his pictorial attention to urban motifs, which he developed into series. This work was one of a group of four Parisian views painted from the Hôtel Garnier in front of the Gare Saint-Lazare and depicts the Rue Saint-Lazare looking eastward, with the silhouette of the Eglise de la Trinité overlooking the façade of buildings.

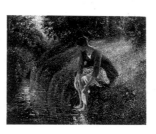

13. *The Foot Bath.* 1895.
Neither fully dressed nor undressed, the model in this sensual painting seemingly ignores the gaze of the artist and tilts her face away from the viewer. As she looks away, the back of her neck is illuminated by the light of the sunset, which also gently highlights the back of her body and the V-neck opening of her shirt.

14. *Woman Breaking Wood.* 1890.
A year after this work was painted, Georges Seurat died. At his funeral Pissarro noted that Pointillism was over. The variety of ways of applying paint on the canvas here reveals the critical transitional phase that Pissarro was undergoing. The work is unified by a whitish scumble spread over the surface that tempers the harsher contrasts and enhances the hoarfrost effect.

15. *Fair Around the Saint-Jacques Church, Dieppe.* 1901.
This is one of nine paintings by Pissarro of the Saint-Jacques Church in Dieppe and its immediate surroundings. Pissarro found in Dieppe a fruitful source of motifs and returned the following year to paint a series of the harbor. The painting sets in opposition themes close to Pissarro's heart: the spiritual versus the material and the eternal versus the ephemeral.

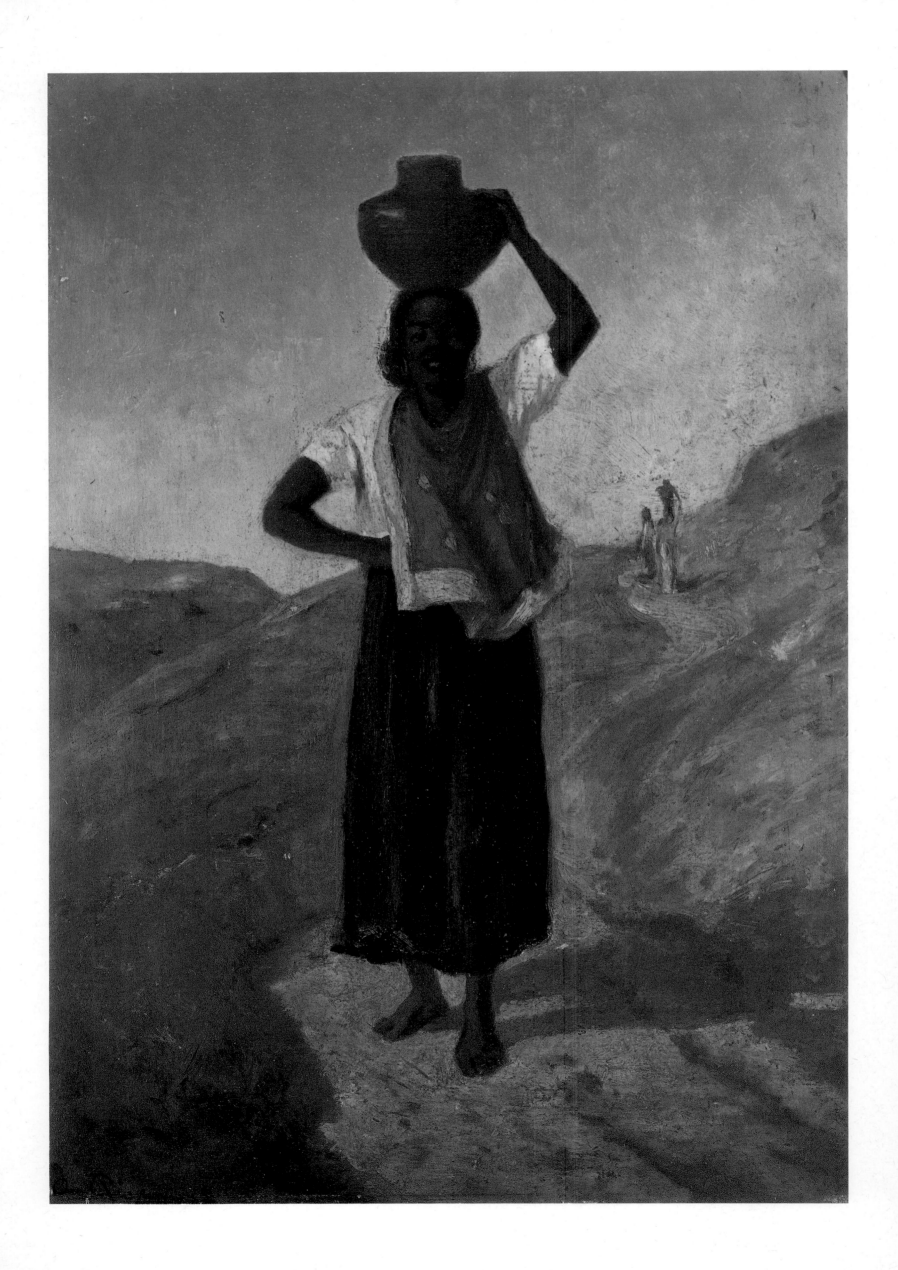

1. *Negress Carrying a Pitcher on Her Head, Saint Thomas.* c.1854–1858.
Oil on canvas, 13 x 9". Foundation E. G. Bührle Collection, Zurich

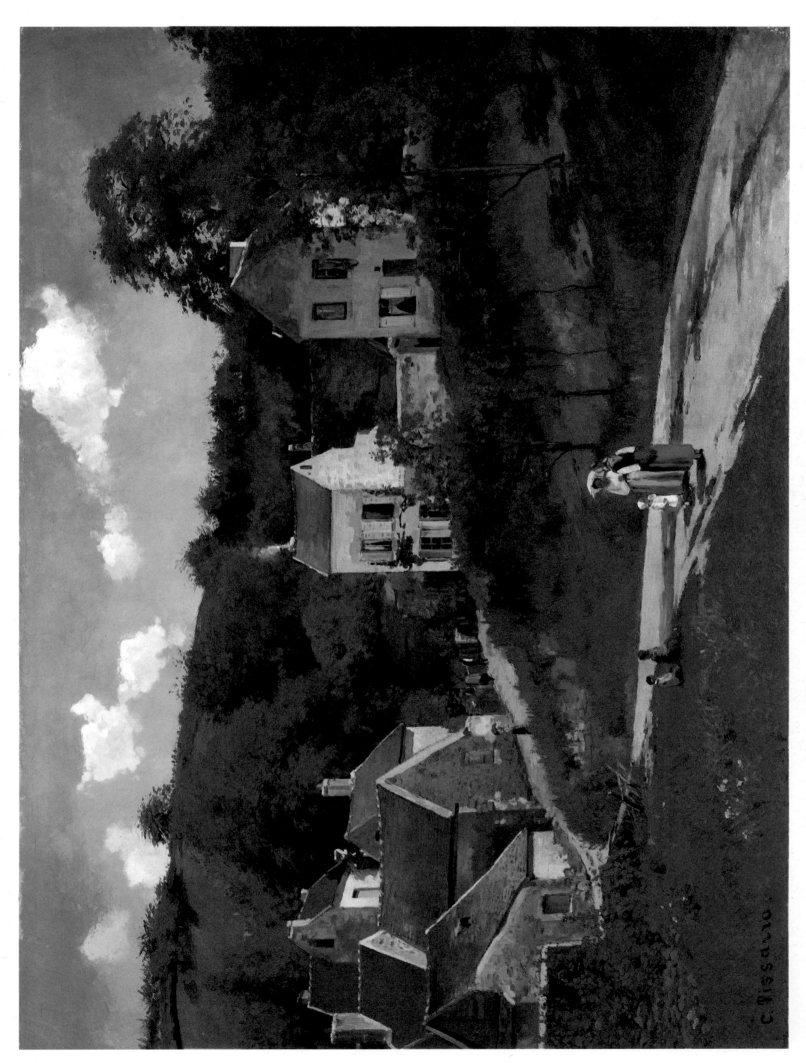

2. *The Hermitage at Pontoise.* c.1867. Oil on canvas, 59⅝ x 79".
Solomon R. Guggenheim Museum, New York. Gift, Justin K. Thannhauser, 1978.
Photograph ©1992 Solomon R. Guggenheim Museum, New York

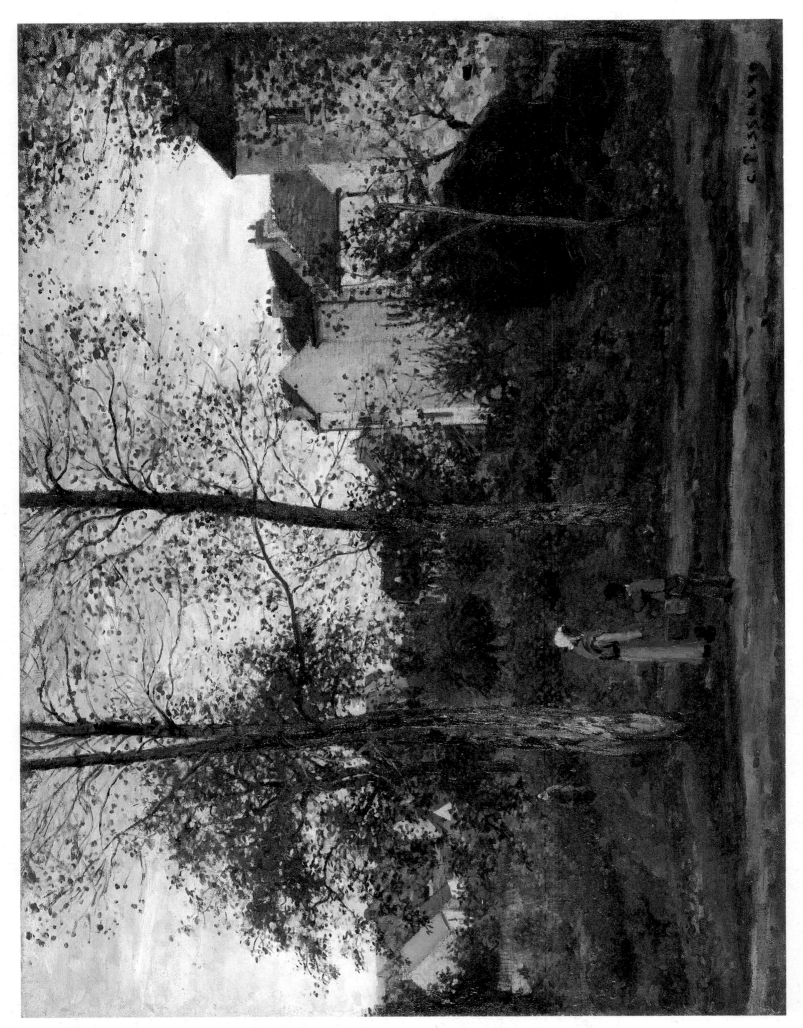

3. *Landscape in the Vicinity of Louveciennes (Autumn)*. 1870. Oil on canvas, 35 x 45¾".
Collection of the J. Paul Getty Museum, Malibu, California

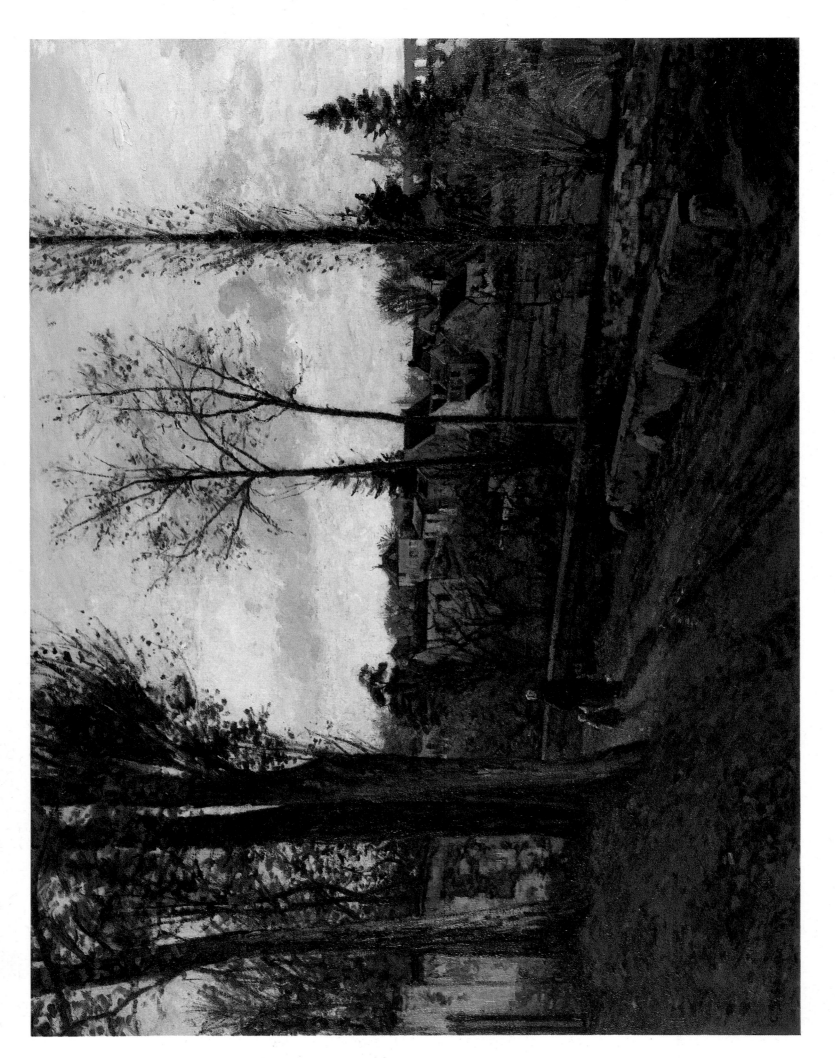

4. *Louveciennes.* 1871. Oil on canvas, 43 x 63".
Private collection

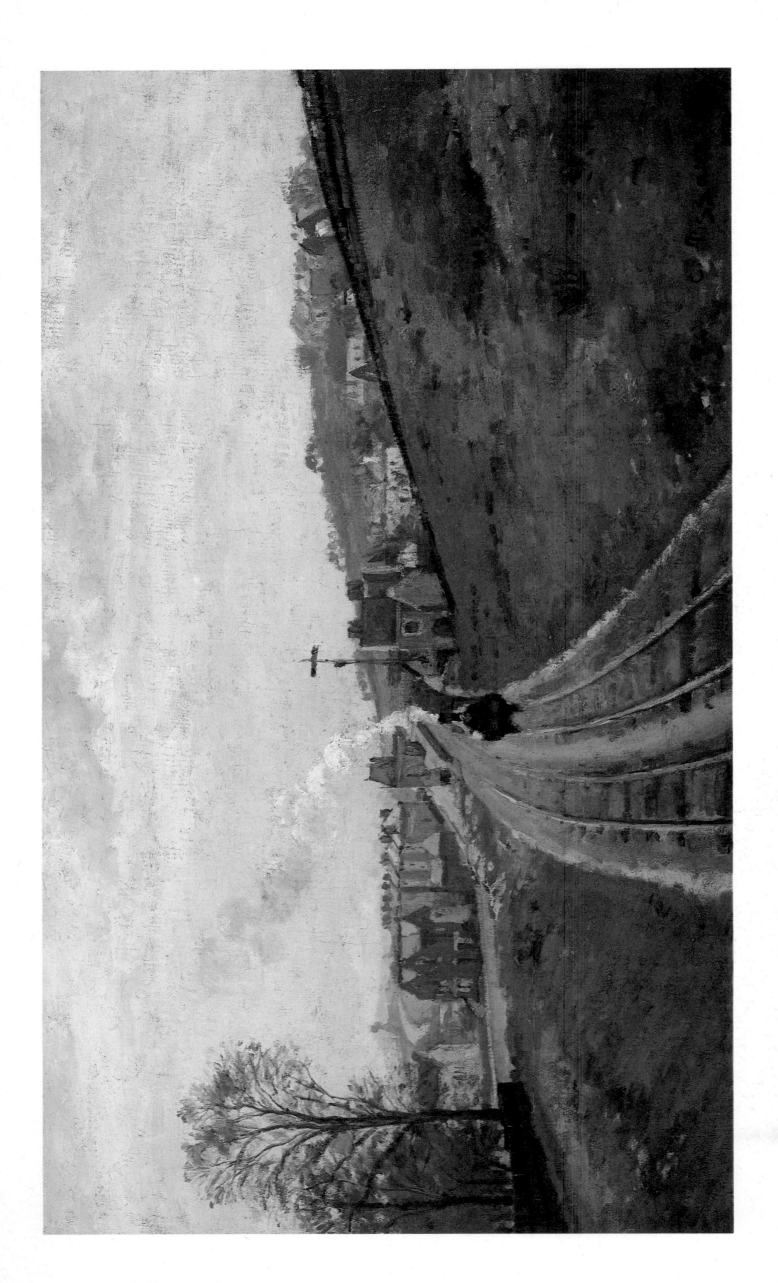

5. *Lordship Lane Station, Dulwich.* 1871. Oil on canvas, 17 x 28".
Courtauld Institute Galleries, London. Courtauld Bequest, 1948

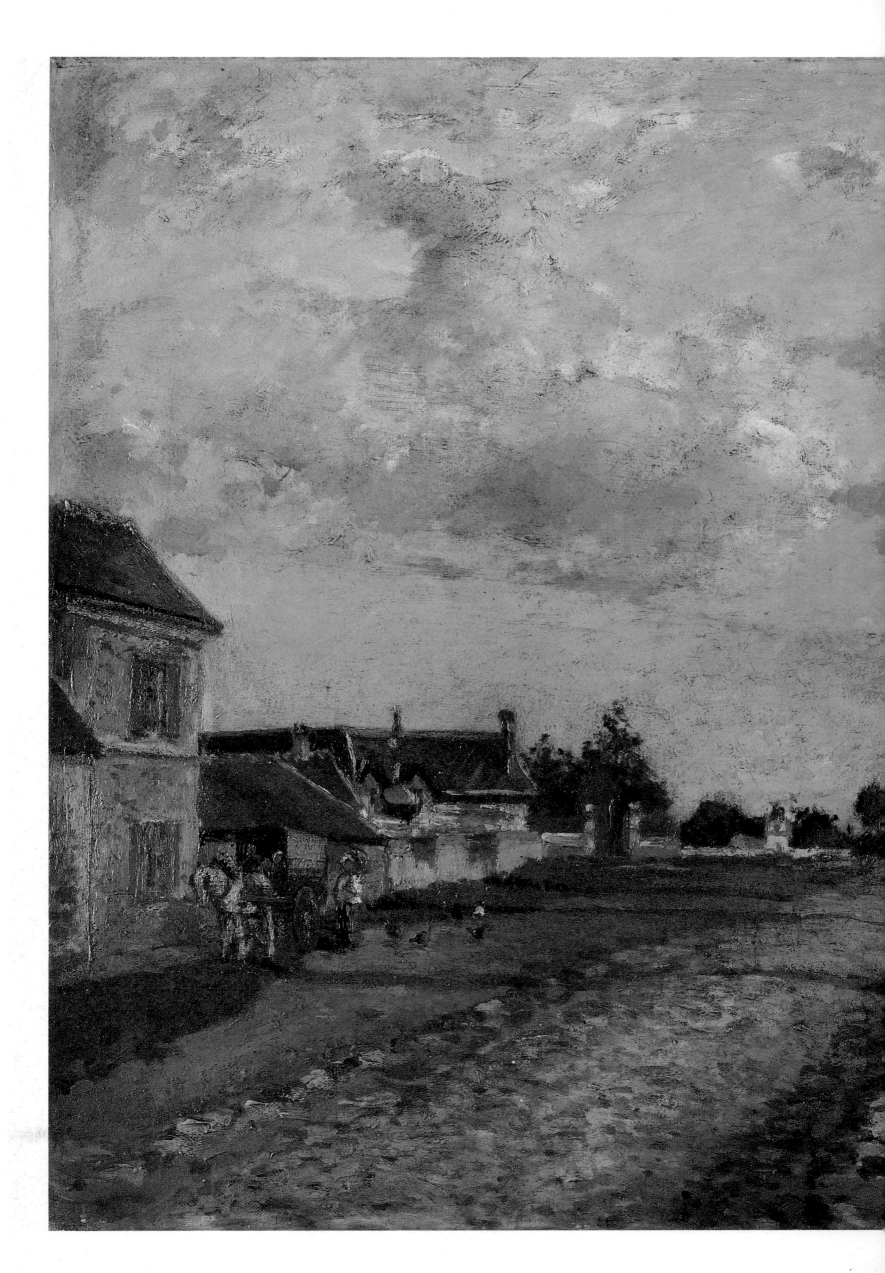

6. *The Rocquencout Road.* 1871. Oil on canvas, 20 x 30".

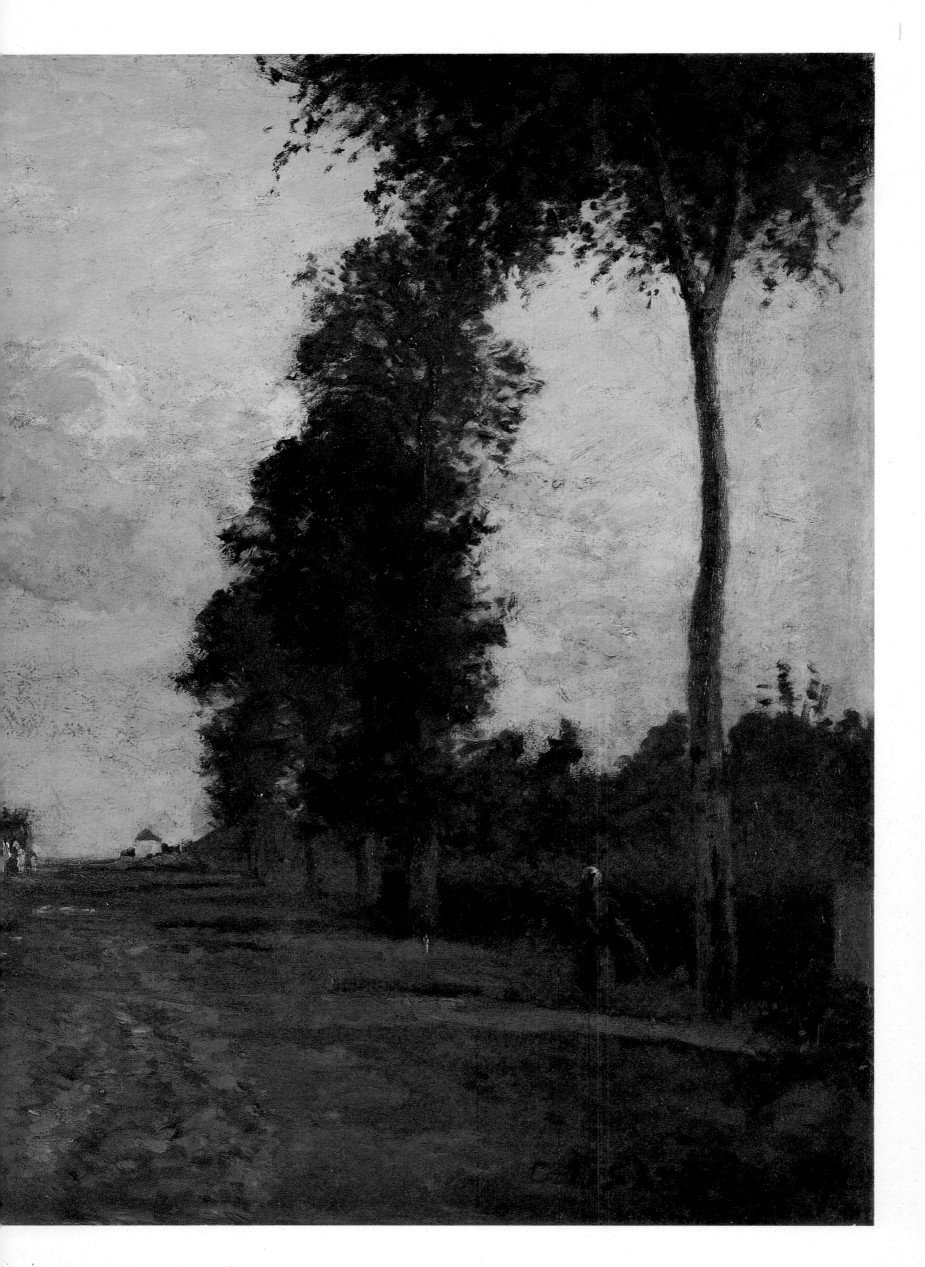

Private collection

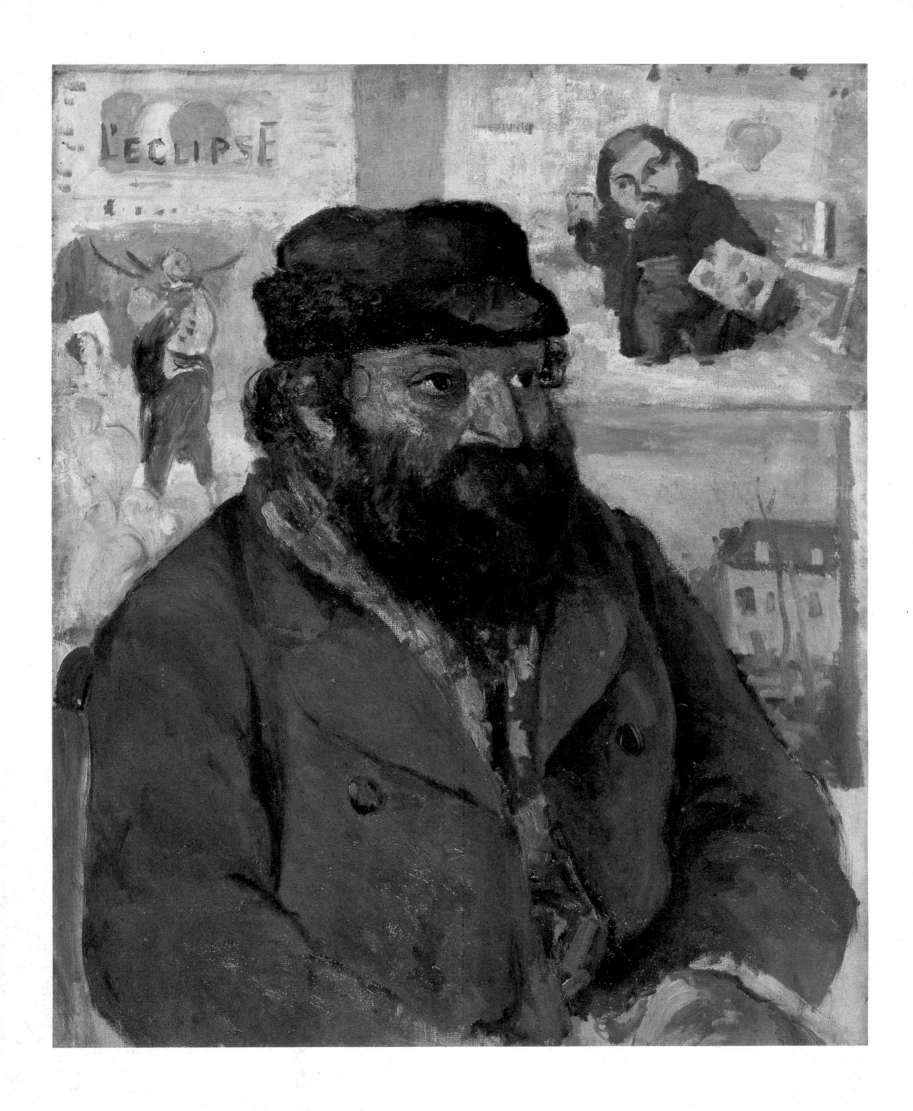

7. *Portrait of Cézanne*. 1874. Oil on canvas, 29 x 24".
Collection Laurence Graff

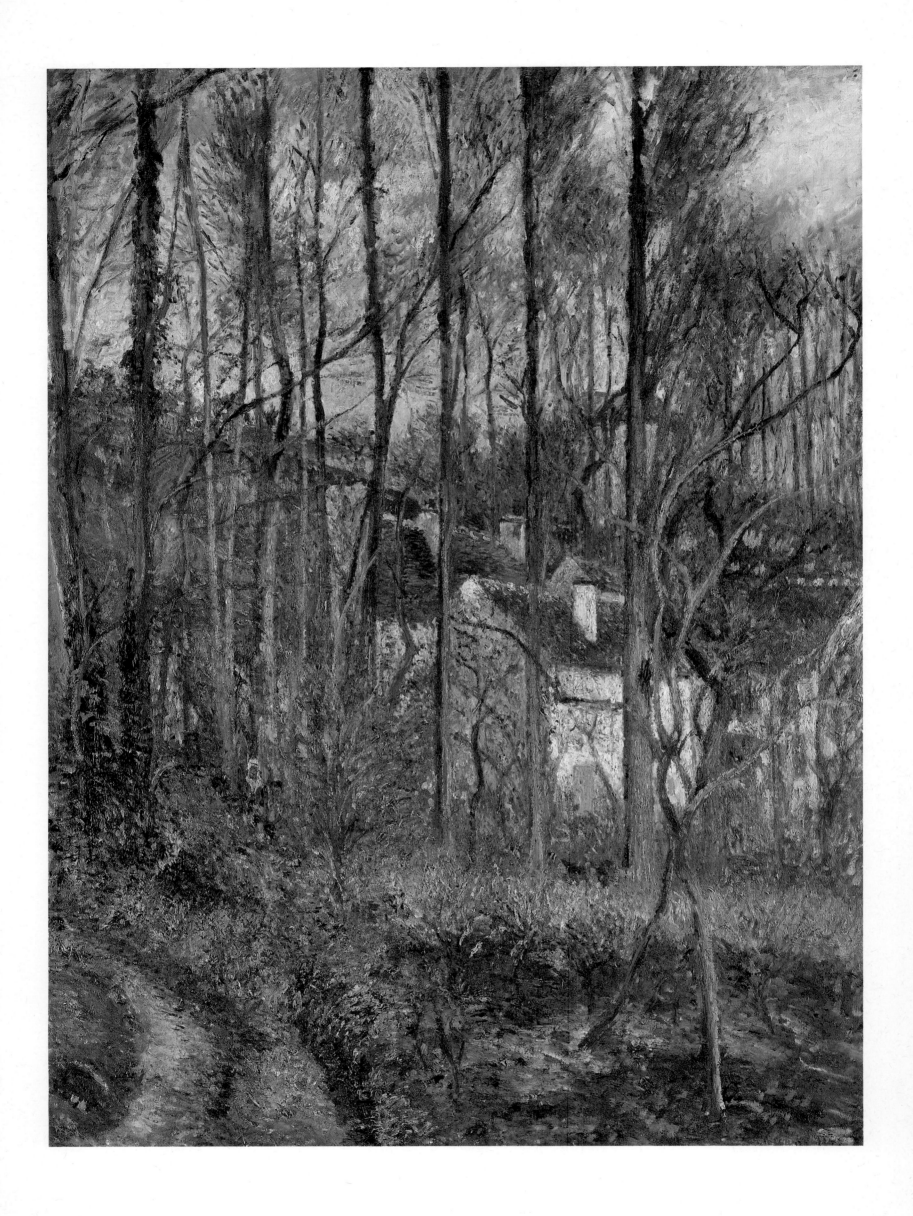

8. *The Côte des Boeufs, Pontoise*. 1877. Oil on canvas, 45 x 34".

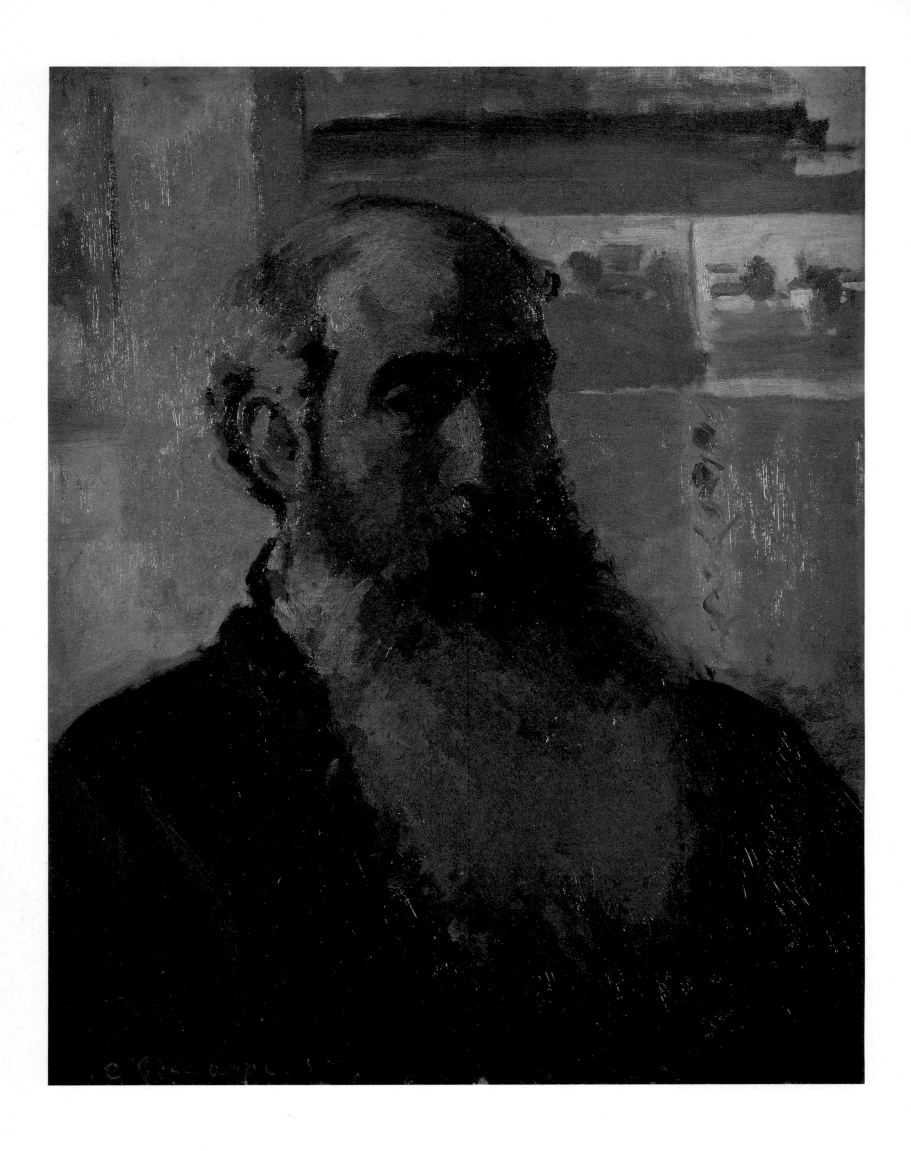

9. *Self-Portrait*. 1873. Oil on canvas, 22 x 18".
Musée d'Orsay, Paris. ©Photograph 1992 Réunion des Musées Nationaux

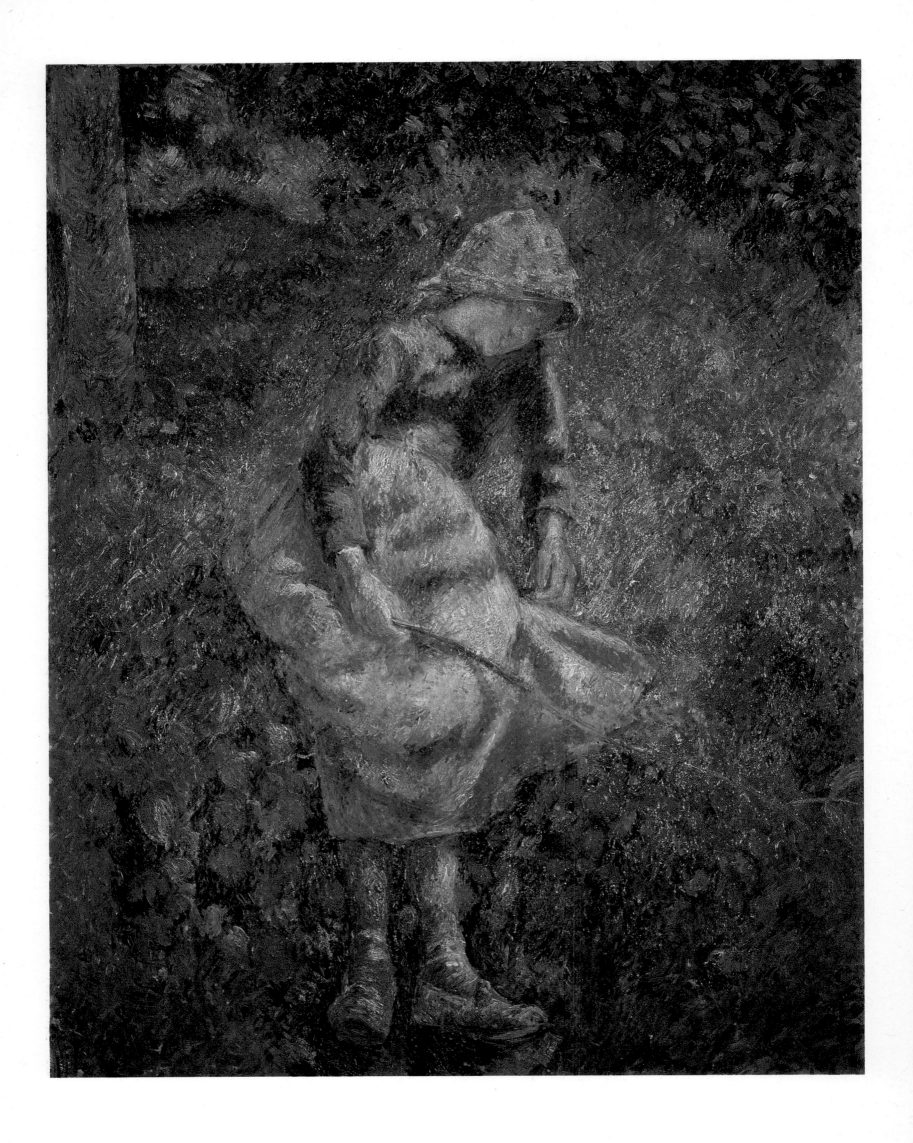

10. *Young Girl with Stick, Seated Countrywoman.* 1881. Oil on canvas, 32 x 26".
Musée d'Orsay, Paris. ©Photograph 1992 Réunion des Musées Nationaux

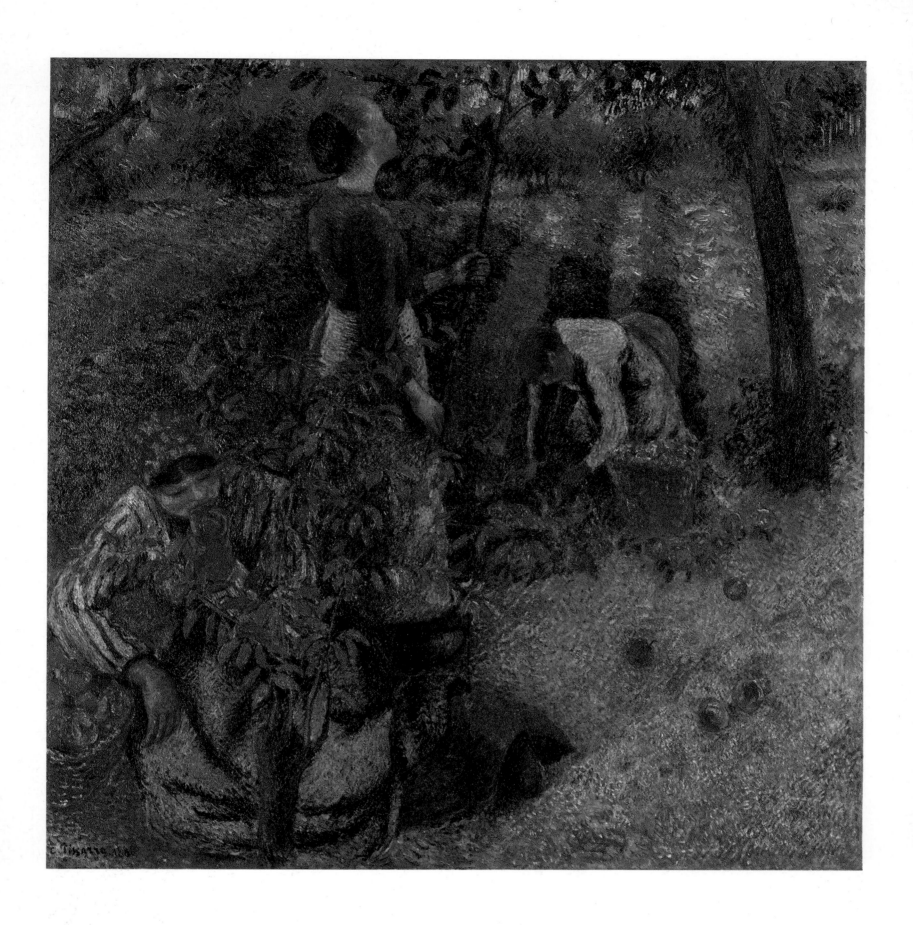

11. *The Apple Pickers*. 1886. Oil on canvas, 50 x 50".
Ohara Museum of Art, Kurashiki, Japan

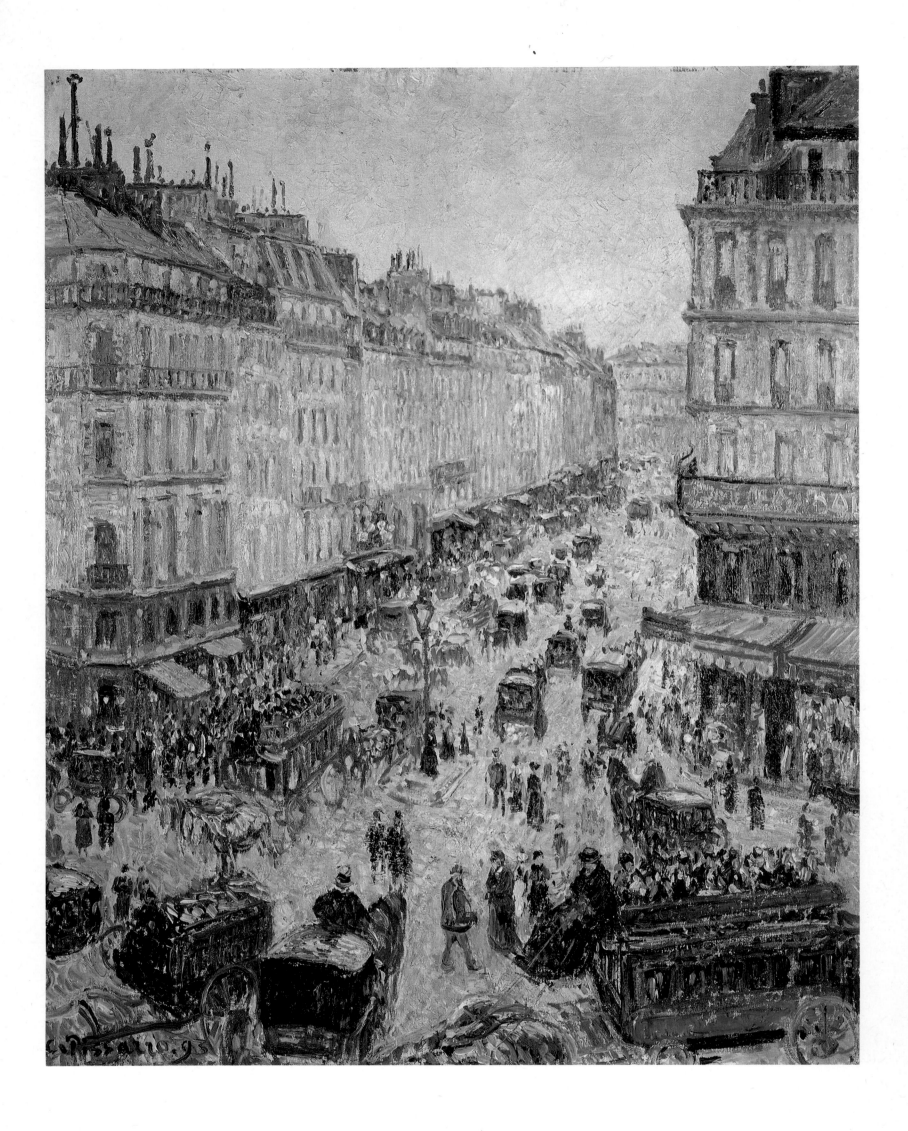

12. *The Rue Saint-Lazare*. 1893. Oil on canvas, 29 x 24".
Private collection

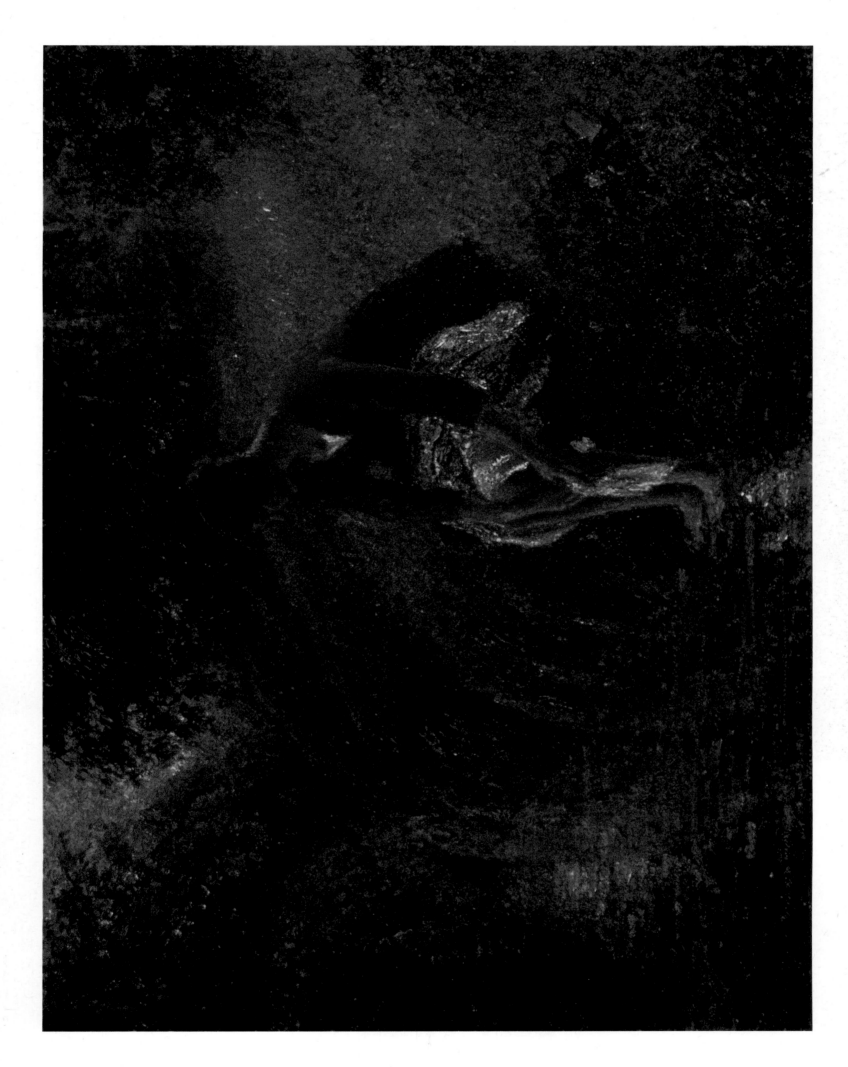

13. *The Foot Bath*. 1895. Oil on canvas, 29 x 36".
Collection Sara Lee Corporation, Chicago, Illinois

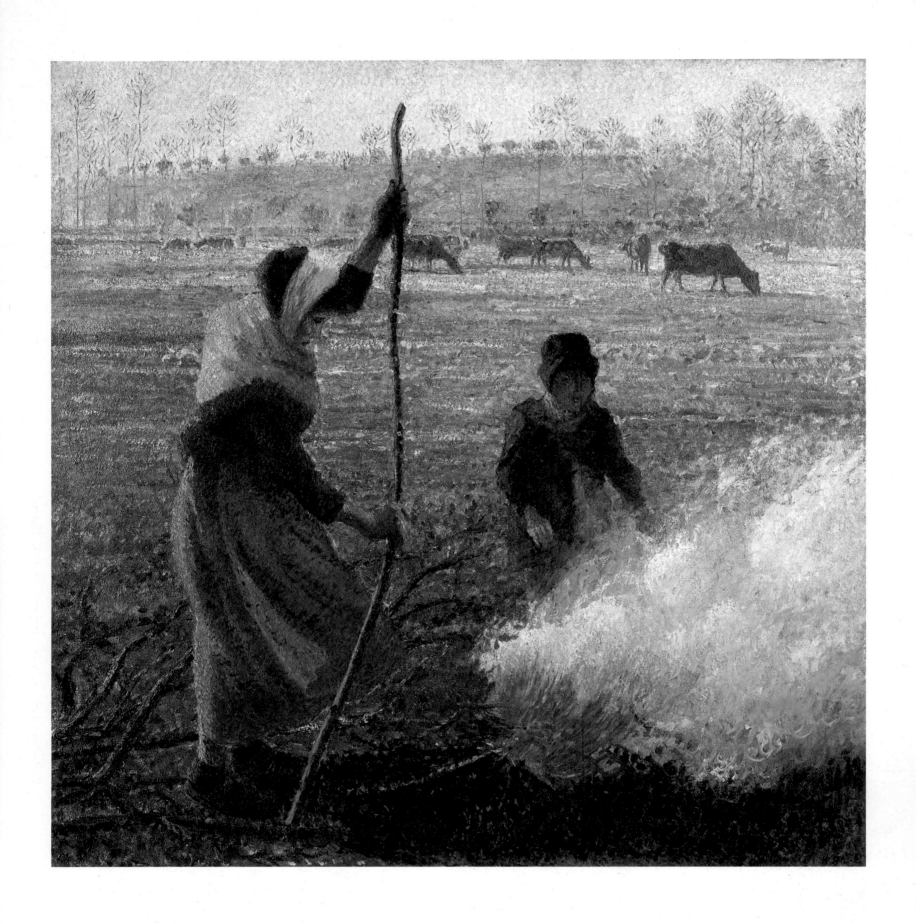

14. *Woman Breaking Wood*. 1890. Oil on canvas, 49 x 50".
Private collection

15. *Fair Around the Saint-Jacques Church, Dieppe.* 1901.
Oil on canvas, 26 x 32". Private collection